Published by Ice House Books

Copyright © 2020 Cakes with Faces
Licensed by This is Iris. www.thisisiris.co.uk

Written & illustrated by Cakes With Faces creator, Amy Crabtree

Ice House Books is an imprint of Half Moon Bay Limited
The Ice House, 124 Walcot Street, Bath, BA1 5BG
www.icehousebooks.co.uk

ISBN 978-1-912867-70-7

Printed in China

Sushi
COMIC BOOK

ICE HOUSE BOOKS

ABOUT
CAKES WITH FACES

1) Cakes with Faces designs are all original art by UK designer Amy Crabtree.

2) I love drawing cute designs to make you smile, and to make every day more fun.

3) It started as a hobby, and now it's my full time job. I design t-shirts, clothing and gifts. You can see them on cakeswithfaces.co.uk

4) I love travelling to Japan, and making travel videos on YouTube. It's also a big inspiration for my artwork.

CAKESWITHFACES.CO.UK

AND MAY RESULT IN LARGE QUANTITIES OF SUSHI BEING EATEN ALIVE.
PLEASE EXERCISE CAUTION. THE KITCHEN IS NOT FOR THE FAINT-HEARTED.

Whenever I'm at home for the weekend, I like to have Sushi Saturday and spend the afternoon making sushi together with friends or family.

It's fun to pass on the sushi skills and make sushi when your friends come round. But practise first so you look like pros!

Of course, becoming a sushi chef takes years of training. An apprentice spends years just cooking the rice. This comic book can't teach you the true art of sushi-making, but it will show you how to make your own sushi to enjoy at home, which is great if, like me, there aren't many Japanese restaurants near you *sniff*.

WHY MAKING YOUR OWN SUSHI IS GREAT

1) Fresh sushi **tastes so much better**. If you've only ever had packaged sushi from a shop, you'll realise how dry it is – it's really nothing like how sushi should be!

2) You can make your sushi **just how you want it**. Have as much or as little wasabi as you want, season the rice exactly to your taste and try whatever crazy fillings you like (with combinations you might never find on a restaurant menu)!

3) Save a **ton of money** compared to going to a fancy restaurant. Sushi's **so expensive** when you're eating out. I always feel like I have to hold back, but if you make your own you can have **as much as you want** without worrying about the bill.

4) It's a fun way to **spend an evening together**. Invite your friends or family round – everyone can join in and have a go at preparing ingredients and rolling sushi!

Everything in this book can be fish or veggie/vegan!

Nori
(seaweed sheets)

Sushi rice

Sushi rice seasoning
(not mirin – that's
something different!)

Wasabi
Comes in a tube or as powder
that you mix with water

Fillings for your sushi rolls!
Cucumber, pepper, tofu, avocado, carrot, salmon …

OPTIONAL:

Pickled ginger

Sesame seeds

Soy sauce

SPECIAL KITCHEN ITEMS:

Rolling mat

Thick-bottomed pan
with lid

Really sharp knife
– not serrated

Important! Fish needs to be super-fresh and kept at a lower temperature to be safe to eat raw. Supermarket fish is probably not ok. Your best bet is salmon. Ask at your market or fishmongers if the fish is ok for sushi, keep it on ice and eat it the day you buy it.

If you can't get sushi rice seasoning you can make it! For 2 people, slightly warm up 11 tablespoons of rice wine vinegar. Mix in 1 teaspoon salt & 4 teaspoons sugar. Cool before use.

FISH FOR SUSHI

Sushi-grade fish is perfectly safe to eat raw, as long as it's been prepared and stored correctly. Here's how to find fish that's safe for sushi, so you can enjoy your nigiri without any worries!

WHERE TO GET FISH FOR SUSHI

Try your local fishmongers, or a fish stall at the market. Always ask if it's safe for sushi – a good fishmonger will know.

WHAT MAKES IT SAFE?

Sushi-grade fish is caught and prepared quickly in a specific way, so it's safe to eat raw. Some types of fish have to be frozen quickly to a lower temperature to kill any parasites.

⚠️ Fish from the supermarket probably isn't sushi-grade. Never eat fish raw unless you know it's safe. If it's not sushi-grade it might contain parasites or make you ill.

Choose fish that looks fresh. Colour isn't necessarily related to freshness – in fact it's sometimes added artificially. Go for a piece that looks firm, fresh and not dull or falling apart. A taller, thicker fillet will be easier to cut.

TYPES OF FISH

There are many types of fish that you can eat raw, but the easiest to get hold of are:

- Salmon

- Tuna

- Scallops

You can also use seafood sticks from the supermarket, or tinned salmon or tuna. However they're completely different to fresh salmon and tuna, so give the fresh versions a try if you can.

HOW TO STORE IT

You'll need to eat the fish on the same day you buy it. You'll need to store it in the fridge on ice.

Just chill...

KEEP IT SHARP!

It's important that your knife is really sharp so it slices through the fish cleanly. Use your sharpest, non-serrated knife.

If you want to invest in a knife for cutting fish, there are lots of different types for sushi. Go for a sashimi knife (also called a yanagi or yanagiba). They're made with thin, pointed blades, perfect for slicing fish.

Keep it sharp and don't scrape it on your chopping board – it ruins the blade!

HOW TO SLICE YOUR FISH

Slicing fish properly for sushi is an art that takes sushi chefs years to learn. But here's how you can slice your fish for sushi at home:

1) First cut the skin off. Hold the end of the skin tightly and slice it off.

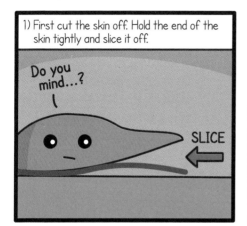

2) If it's a wide fillet, cut it in half or thirds first, then slice for nigiri-size pieces:

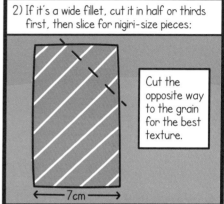

Cut the opposite way to the grain for the best texture.

3) Keep the knife at an angle to get a larger slice.

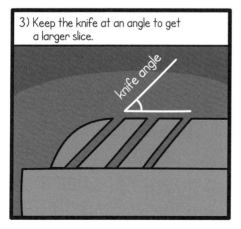

4) If your fillet isn't tall enough for that, cut horizontal slices first, then cut into rectangles. Try for a nice arrow pattern!

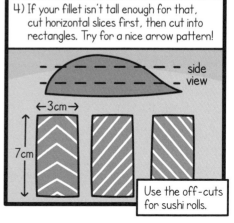

Use the off-cuts for sushi rolls.

IDEAS FOR
SUSHI FILLINGS

Sushi refers to the method of preparing rolls and nigiri with seasoned rice – so the fillings can be anything you like! It doesn't even have to be fish. Experiment with different fillings, use what you have in the fridge and see which you like best!

Cucumber

Carrot
(grate or steam lightly)

Pepper

Avocado

Asparagus

Chopped spring onion

Beetroot

Finely grated radish
or pickled daikon radish

Sweet potato
(steam or bake)

Salmon or tuna strips
(make sure it's safe for sushi)

Tinned salmon

Seafood sticks

Tuna mayo

Marinated tofu

Inari sushi pockets
(sweet tofu) cut into strips

Tamago
(sweet egg omelette)

Mayonnaise,
salad cream
or cream cheese

Pickled ginger

Lettuce

Sweet sushi
with mango

Strawberries
& whipped cream!

WHERE TO GET INGREDIENTS

The first time you make sushi, it might seem like you need to get a lot of things, but many of them will last for more than one meal. So the next time you might only need to buy the fresh ingredients.

Asian food stores – even shops with mainly Chinese food often stock a small section of Japanese items too. If there isn't a shop locally, there might be a stall at your local market.

Large supermarkets sometimes have sushi rice, nori and seasoning in their "World Foods" aisle.

click click

Online shopping is a way to stock up if you don't have anywhere nearby.

WASABI

Wasabi was originally added to sushi to prevent food poisoning. Today it's just for flavour — and when you make your own you can add as much or as little as you like!

The heat isn't spicy like chilli — you feel it in your nose more than your tongue, like with horseradish.

In fact, it's in the same plant family as horseradish — and cabbage!

My long-lost cousin!

Just add water!

In Japan you can even get wasabi ice cream!

You can get wasabi paste in a tube or powder from Asian food shops, online and sometimes from large supermarkets. With the powder, mix it with a little water to make a paste.

IS IT HEALTHY?
Wasabi contains lots of vitamins and antioxidants. It's also antibacterial, reduces inflammation and has even been thought to help prevent some types of cancer and heart disease, and ease the effects of arthritis.

MOST WASABI ISN'T REAL!

Most wasabi paste in the UK (even in restaurants) contains little or no real wasabi! It's usually a mixture of horseradish, mustard and green food colouring.

That's because wasabi is difficult to grow — it has very precise requirements. It needs cool shade and flowing water.

Real wasabi is delicate and fragrant.
It's more about the flavour than just the heat.

WHERE TO GET REAL WASABI

There's a farm that grows real wasabi in the UK, which you can buy online. You can get fresh wasabi roots, powder that contains real wasabi, and even plants to try growing your own wasabi at home.

Although it's pricier than paste, I'd recommend you try fresh wasabi at least once to see what it's like — maybe on a special occasion.

HOW TO PREPARE FRESH WASABI

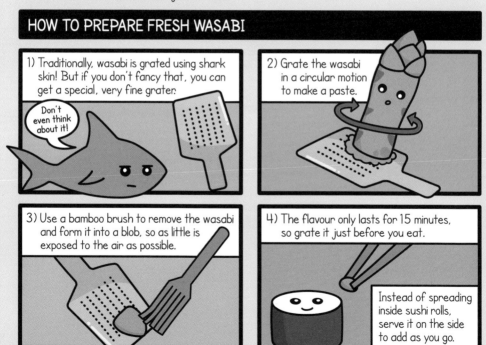

1) Traditionally, wasabi is grated using shark skin! But if you don't fancy that, you can get a special, very fine grater.

Don't even think about it!

2) Grate the wasabi in a circular motion to make a paste.

3) Use a bamboo brush to remove the wasabi and form it into a blob, so as little is exposed to the air as possible.

4) The flavour only lasts for 15 minutes, so grate it just before you eat.

Instead of spreading inside sushi rolls, serve it on the side to add as you go.

BASIC SUSHI ROLLS

1) Wash the rice more times than you think you need to, add the exact amount of water and boil. As soon as it boils, reduce the heat and simmer for 10 minutes. Then remove from the heat and leave for 12 minutes.

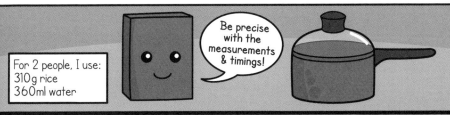

2) Resist the temptation to lift the lid or the water will escape as steam!

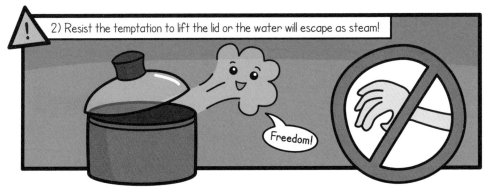

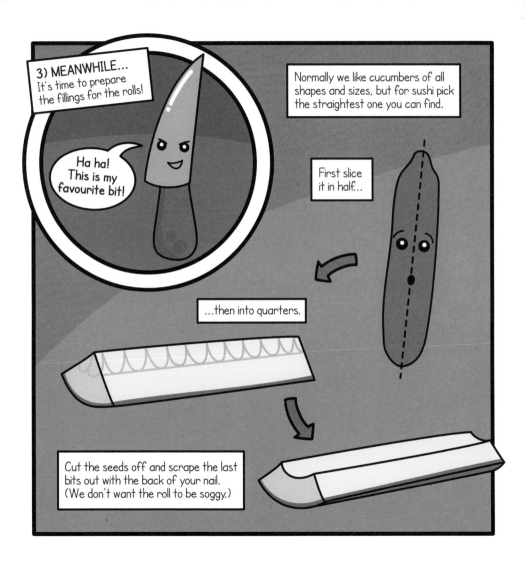

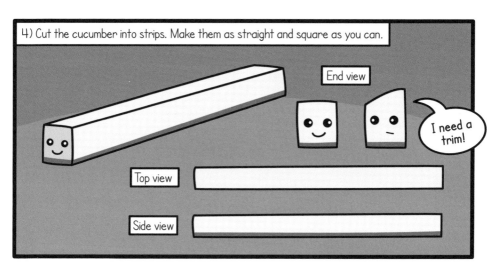

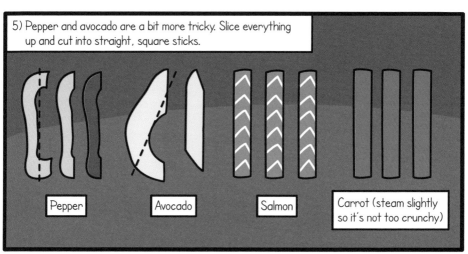

6) The rice should be ready by now. Tip it out into a wooden bowl or casserole dish and fan to cool it down.

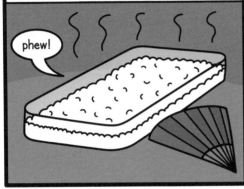

7) Add the seasoning and gently mix until each grain is lightly coated (about 1/3 bottle). Taste to check if it's right!

8) Cover the rice with a damp tea towel so it doesn't dry out.

9) Grab a sheet of nori and cut it in half.

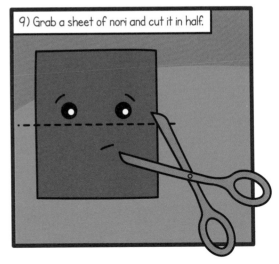

10) One side of the nori is more shiny.

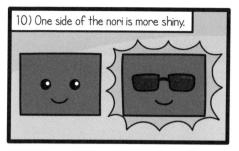

11) Put the shiny side down on the rolling mat.

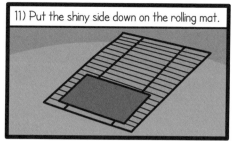

12) Wet your hands and grab a ball of rice. Arrange the rice so it's 2 or 3 grains thick on the nori. You'll need to cover the whole sheet except a strip along the top (about 3 cm).

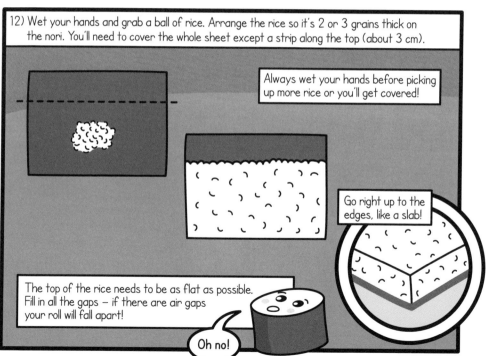

Always wet your hands before picking up more rice or you'll get covered!

Go right up to the edges, like a slab!

The top of the rice needs to be as flat as possible. Fill in all the gaps — if there are air gaps your roll will fall apart!

Oh no!

13) Place the filling on the rice, about a third of the way in.

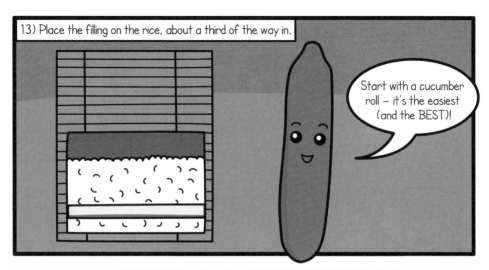

Start with a cucumber roll – it's the easiest (and the BEST)!

14) With your finger, smooth a touch of wasabi onto the filling.

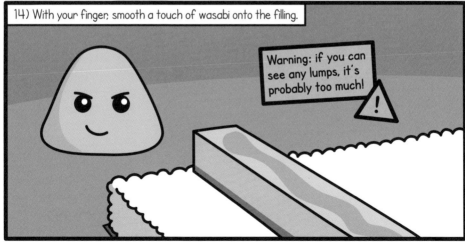

Warning: if you can see any lumps, it's probably too much!

ARE YOU READY TO ROLL?

First place your fingers on the filling to hold it in place.

15) Tuck your thumbs under the mat and roll it over to the halfway position:

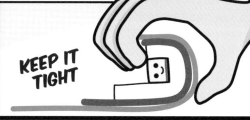

KEEP IT TIGHT

16) Roll it completely around. Keep it tight and pinch in slightly to keep it together.

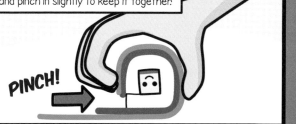

PINCH!

17) Lift the end of the mat so it doesn't get caught in the roll. With an even pressure, roll forwards and backwards.

wheeee!!!

18) Admire your roll!

TA-DAH!

19) If it's splitting open, next time leave a bigger gap along the top of the nori.

Avert your eyes!

20) Move the roll on to a chopping board — first we're going to cut it in half.

Whaaaaat?!

21) Lay the rolling mat over the roll and use it to pin the roll to the chopping board.

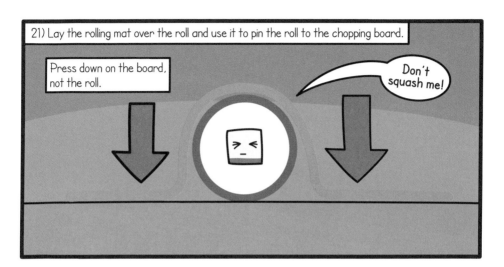

22) First cut it in half. Wet the knife and cut with a small, quick sawing motion at a 45° angle. Don't use too much pressure, or the roll will get squashed!

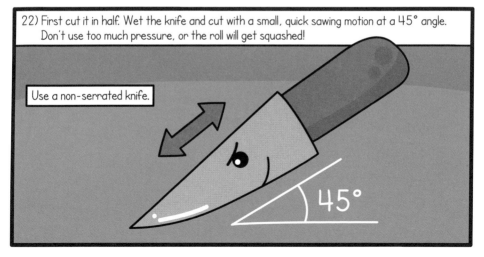

23) If your roll looks like this, WELL DONE! The perfect roll has the filling exactly in the centre.

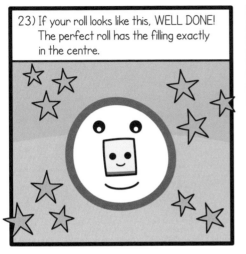

24) Now cut up the rest of the roll. Flip one half around and cut them both together.

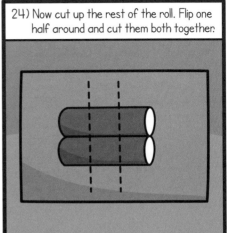

25) Try and cut all the rolls the same height so they look nice as a set.

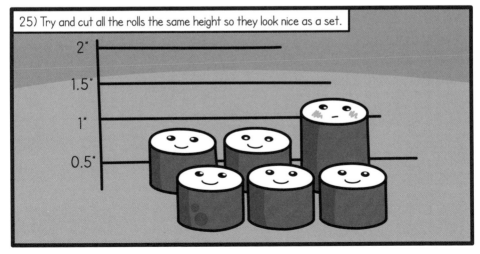

26) If they come out a bit squashed, make them tear-drop shaped and arrange them like a flower, as if they were meant to be like that all along (no one will ever know!).

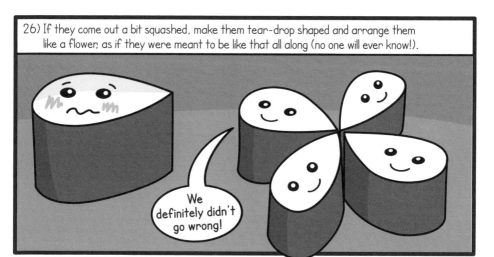

27) Serve your sushi with ...

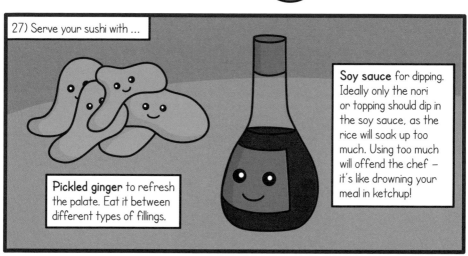

Pickled ginger to refresh the palate. Eat it between different types of fillings.

Soy sauce for dipping. Ideally only the nori or topping should dip in the soy sauce, as the rice will soak up too much. Using too much will offend the chef – it's like drowning your meal in ketchup!

FUTOMAKI (GIANT ROLL)

1) Instead of cutting the nori in half, use a whole sheet!

2) Place it shiny side down on the rolling mat.

And relax...

3) Cover the whole sheet in rice (apart from a strip at the top) about 2 or 3 grains thick, very neatly.

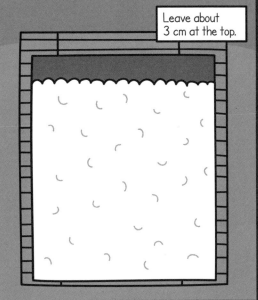

Leave about 3 cm at the top.

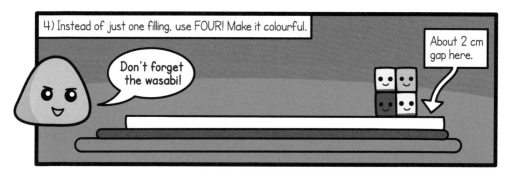

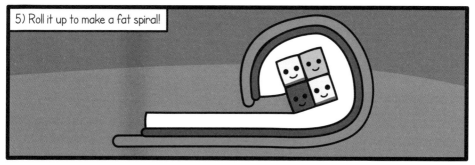

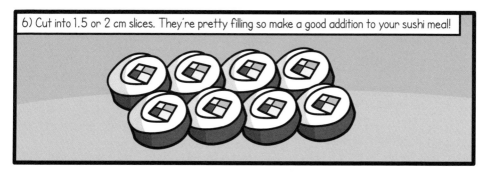

NIGIRI

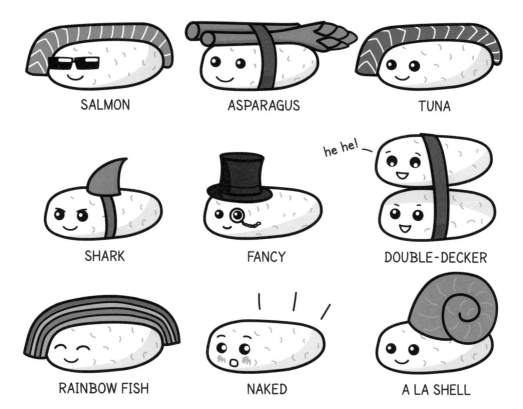

SALMON

ASPARAGUS

TUNA

SHARK

FANCY

he he!

DOUBLE-DECKER

RAINBOW FISH

NAKED

A LA SHELL

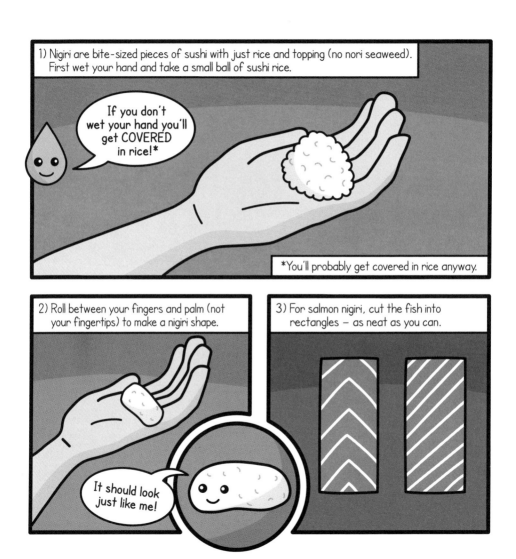

4) Add a dab of wasabi to the salmon and lay it over the rice ball.

5) Traditionally, nigiri is always served in pairs.

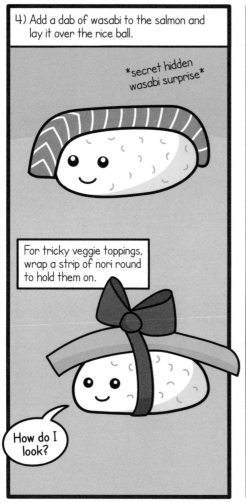

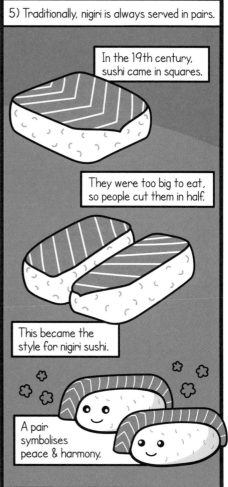

EDAMAME

1) Edamame are soybeans served in their pods. They make a great side dish for sushi!

2) They come frozen in packs — boil them for a couple of minutes so they soften slightly.

If the pods start splitting open, they're overcooked!

3) Drain, cool with cold water, add salt & mix.

4) Serve in pods, but don't eat the pods — squeeze the beans out with your teeth.

GYOZA

1) Gyoza are Japanese dumplings. You can buy them frozen from Asian shops.

You can get veg & meat fillings. My fav is kimchi!

2) Cook from frozen. Fry until lightly browned on the base.

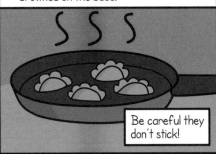

Be careful they don't stick!

3) Carefully add about 1 cm of water and cover the pan with a lid. Cook until the water has evaporated. Make sure they are piping hot throughout.

Private sauna!

4) Mix soy sauce with a few drops of rice wine vinegar (or any clear vinegar) for dipping.

CONVEYOR BELT SUSHI

Conveyor belt sushi (kaitenzushi) restaurants are everywhere in Japan, it's not hard to find them! They're a fun experience and a great way to try lots of different types of sushi.

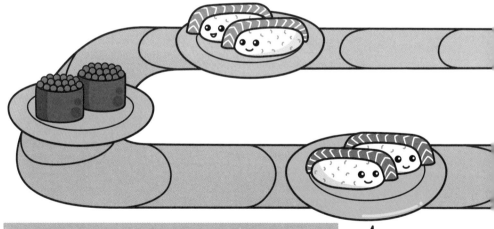

The ideal speed for the conveyor belt is said to be:
8 cm per second
If it's faster the sushi dries out. If it's slower, people get impatient!

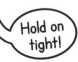

Hold on tight!

IS IT EXPENSIVE?

It's usually quite cheap – sometimes even as little as 100 yen (about 70p) per plate for the cheapest options.

The sushi isn't as carefully made as more expensive restaurants, but it's still fresh and of an excellent quality.

HOW TO ORDER

- Choose plates you like from the belt.
 (Usually there's a menu to order from too.)
- Some places have a touchscreen for placing your order! (Look for an English language option.)
- Dishes are colour-coded by price.
- Don't put anything back on the belt – if you pick up a dish you have to eat it.
- Stack your empty plates up into a tower.
- When you're finished, call over the waiter and they'll prepare the bill for you to pay at the till.

wheeee!!

HOW WAS IT INVENTED?

The first conveyor-belt sushi bar was in Osaka in 1958. The owner wanted a way to serve more people without having to take on extra staff. He also invented a restaurant with robot waiters, but that didn't catch on!

INSIDE-OUT ROLL

Inside-out rolls have the nori seaweed on the inside and the rice on the outside! If you're not keen on the texture of the seaweed, you might prefer this type of roll.

1) First prepare the sushi rice and cut your fillings into strips, the same as for regular sushi rolls.

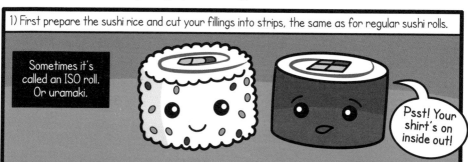

2) Use a whole sheet of nori. Place it on the rolling mat, shiny side down.

3) Cover the whole sheet of nori with seasoned sushi rice.

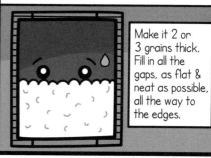

4) Sprinkle on sesame seeds or a seasoning of your choice!

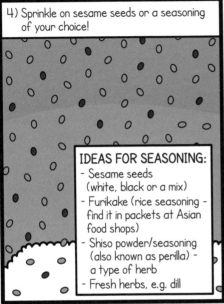

IDEAS FOR SEASONING:
- Sesame seeds (white, black or a mix)
- Furikake (rice seasoning - find it in packets at Asian food shops)
- Shiso powder/seasoning (also known as perilla) - a type of herb
- Fresh herbs, e.g. dill

5) Carefully pick up the nori from one end – we're going to flip it over!

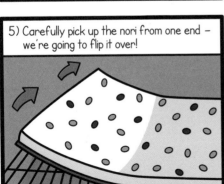

6) Be careful and the rice should cling on! Lay it rice-side-down on the rolling mat.

7) Add your fillings. Use several, like in the giant roll.

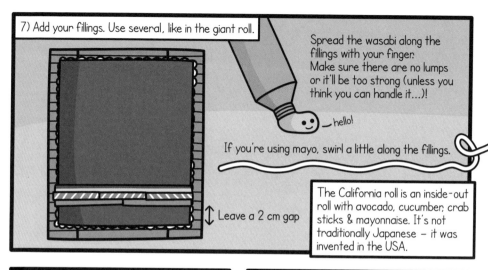

Spread the wasabi along the fillings with your finger. Make sure there are no lumps or it'll be too strong (unless you think you can handle it...)!

— hello!

If you're using mayo, swirl a little along the fillings.

Leave a 2 cm gap

The California roll is an inside-out roll with avocado, cucumber, crab sticks & mayonnaise. It's not traditionally Japanese – it was invented in the USA.

8) Roll it up like a regular sushi roll.

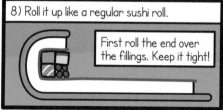

First roll the end over the fillings. Keep it tight!

9) Take it all the way round & pinch in the end.

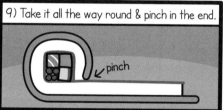

pinch

10) Roll forwards tightly.

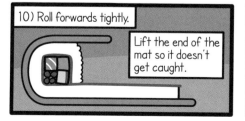

Lift the end of the mat so it doesn't get caught.

11)

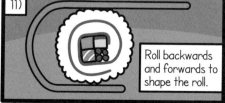

Roll backwards and forwards to shape the roll.

12) Cut the roll up into slices.

Use the rolling mat to hold the roll in place. Press down on the mat so you don't squash the roll!

Use your sharpest non-serrated knife

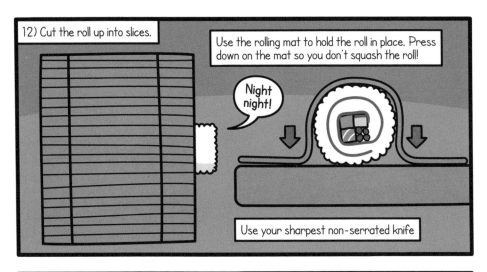

13) Sometimes they turn out square-shaped — and that's ok too!

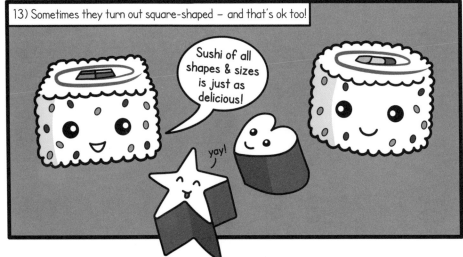

TEMAKI

1) Temaki are sushi hand-rolls; they're cone-shaped like an ice cream!

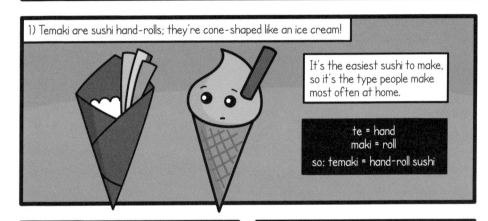

It's the easiest sushi to make, so it's the type people make most often at home.

te = hand
maki = roll
so: temaki = hand-roll sushi

2) Cut your fillings into strips. You can even use leftovers & off-cuts from sushi rolls — these don't have to be so precise.

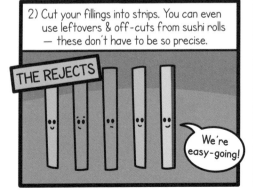

THE REJECTS

We're easy-going!

3) Cook & season the sushi rice the same as for the rolls. Take half a sheet of nori.

Shiny side down!

4) Spread the rice on one half, in a rough triangle shape. Make it a little thicker than the sushi rolls – about 4 grains thick.

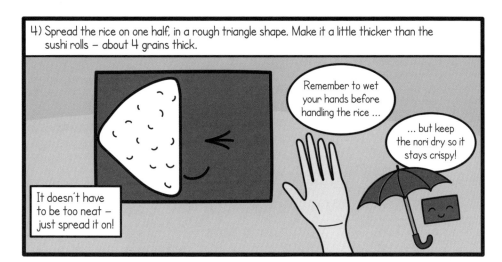

5) Add your fillings towards the top. It's ok to have them poking out the top!

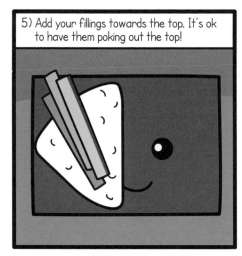

6) Spread on a little wasabi and/or any sauce or sesame seeds.

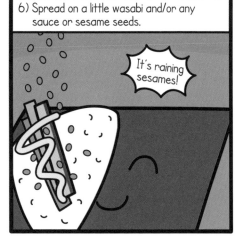

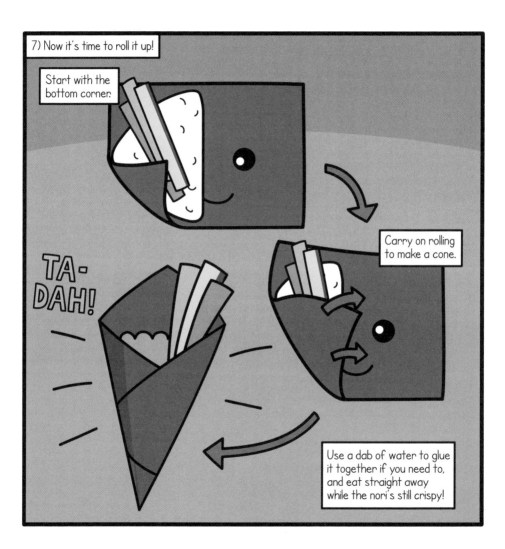

IDEAS FOR
TEMAKI FILLINGS

VEGGIES

Leftover fillings from sushi rolls

Veg cut into strips: pepper,
carrot (slice thinly or grate),
cucumber, beetroot, asparagus

Grated radish

Lettuce

Shiso leaf

Avocado

FISH

Salmon or tuna strips
(make sure it's safe for sushi)

Seafood sticks

Tinned tuna & mayonnaise

Tinned or smoked salmon

EGGS & TOFU

Marinated tofu strips

Inari (tofu) sushi pockets
cut into strips

Tamago
(sweet egg omelette)

SAUCE & SEASONING

Mayonnaise

Salad cream

Sesame seeds

Wasabi

DASHI

Dashi is a light, clear stock that's used in a LOT of Japanese recipes. You'll need it to make miso soup and tamago. You can buy bottles of dashi or granules from Asian food shops, or make your own! There are various types:

Bonito dashi (fish stock) made with bonito fish flakes

Konbu dashi (vegetarian/vegan) made with seaweed.

1) Rehydrate a postcard-sized sheet of konbu seaweed in a saucepan in 500ml cold water for 30 mins.

> Optional: add a couple of dried shiitake mushrooms.

2) Turn on the heat. Before it boils, remove the konbu and take it off the heat.

> Konbu goes slimy & tastes bad if it boils!

3) *Skip this step for vegetarian dashi.* Add 20g bonito flakes and leave for 1 min.

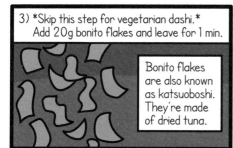

> Bonito flakes are also known as katsuoboshi. They're made of dried tuna.

4) Drain through a fine sieve (with kitchen roll if necessary) to remove all the bits.

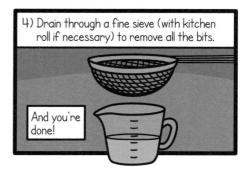

> And you're done!

TAMAGO

Tamago is sweet rolled egg omelette. You can eat it on its own or in sushi:

Pour over a dashi-based broth or dip in soy sauce.

Use as a topping for nigiri sushi.

hello!

Cut strips for temaki hand rolls or futomaki.

You can get a special square pan for making tamago. If you don't have one, use a regular frying pan or skillet.

If you use a round pan, your tamago will be rounded at the ends instead of rectangular!

YOU WILL NEED:

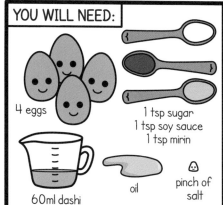

4 eggs

1 tsp sugar
1 tsp soy sauce
1 tsp mirin

60ml dashi

oil

pinch of salt

1) Mix the eggs with chopsticks to break up the yolks. Then mix in the dashi, mirin, soy sauce, sugar and salt.

2) Oil the pan and wipe it with kitchen roll to make sure the whole surface is covered.

3) Heat it up and pour on a thin layer of the egg mixture. Swirl gently to cover the bottom of the pan.

4) Burst any bubbles with your chopsticks!

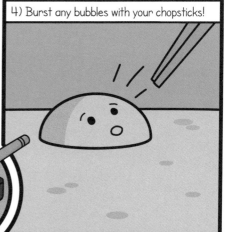

5) When the bottom's cooked but still slightly liquid on top, fold over the edge and roll it up.

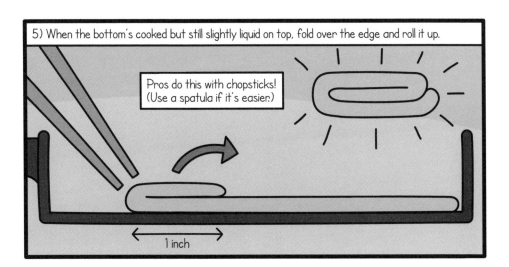

6) Push the roll to the end of the pan and re-oil with the oily kitchen roll if needed.

7) Pour another layer of the egg mixture. Lift the roll so it flows underneath.

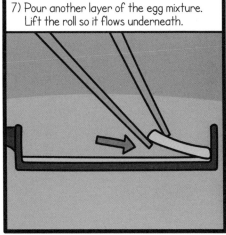

8) Keep rolling and pouring on layers until all the mixture is used up.

9) Wrap the egg roll in kitchen roll and leave for a few minutes.

10) Cut into slices and it's ready! Serve with finely grated radish and dip into soy sauce, or use in your sushi!

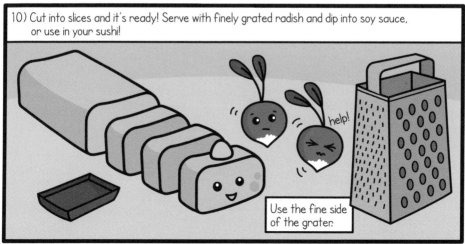

MISO SOUP

A common side dish for all sorts of meals (including traditional Japanese breakfast!) and a tasty addition to your sushi feast. Miso is very healthy – it's made of fermented soybeans (sounds delicious, right?). It's full of protein, vitamins and **good bacteria**.

UMAMI

Umami is a type of flavour in Japanese cuisine, like sweet or salty. Umami is savoury and satisfying; almost "meaty", like marmite, gravy, tasty cheese and tomato on pizza, and dashi stock. Miso is full of umami!

We're the good guys!

TYPES OF MISO

White – The most common, versatile type. If it's just labelled "miso", it's probably white miso.

Red – Contains barley & grains for a stronger, richer flavour.

Yellow – Has a surprising, sweeter taste.

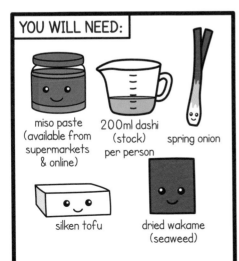

YOU WILL NEED:

miso paste (available from supermarkets & online)

200ml dashi (stock) per person

spring onion

silken tofu

dried wakame (seaweed)

1) First put the wakame into water to rehydrate for 30 minutes.

PS: Bubblebath will not enhance the flavour & may result in poisonous soup!

2) Then prepare your toppings:

3) Cut the wakame into strips.

Scissors are more effective than a shredder!

4) Bring the dashi to the boil, then lower the heat (you can add finely sliced ginger, garlic or chillies for a different flavour).

5) Add 1 tbsp of miso per person. Use a mini sieve and let it dissolve, or mix with a small amount of dashi first to prevent lumps.

6) Add the tofu cubes and warm through for a moment.

7) Put the wakame and spring onions in the bowls and pour over the soup. Experiment with different toppings!

To make it a whole meal, serve miso over noodles with vegetables (e.g. beansprouts, cabbage, leeks, sweetcorn) and/or grilled fish.

SUSHI IN JAPAN

Sushi's often thought of as fine dining, but it started off as street food. In Japan you can get expensive sushi at fancy restaurants, but there's also cheap conveyor-belt sushi, and stand-up sushi bars with no seats – where you just grab a quick bite and go!

Sushi in Japan is quite simple, focusing on the quality and freshness of the ingredients. The most common type is nigiri.

Sushi covered in sauce with multiple ingredients, like dragon rolls and volcano rolls, are western and aren't traditionally Japanese.

It didn't smell too great…

寿司
SU SHI
す し

Su means vinegar or acidic liquids for pickling, like citrus juice.

Shi comes from "me**shi**" which means steamed rice.

So … su-shi = vinegared rice

Sushi was first invented as a way of preserving fish. It was kept in salted, fermented rice for months (even up to a year!). Originally you only ate the fish – the rice was just there to preserve it.

It's ok to pick up sushi with your hands — you don't have to use chopsticks. In fact, with fingers was the traditional way of eating it!

IN WHICH ORDER SHOULD YOU EAT SUSHI?

Whichever order you fancy! But traditionally, it's thought to taste best in this order:

we're refined!

Start with lighter white fish so you can appreciate the subtle taste.

HOW TO BECOME A SUSHI CHEF:

Sushi is an art form and it takes years to become a master sushi chef. You start as an apprentice on cleaning duty. Then you spend years just perfecting the art of cooking the rice, before you're allowed to help with simple prep tasks or even touch a knife! (We won't tell anyone if you dive straight in.)

Then move on to heavier, fattier red fish.

Maki rolls come afterwards with refreshing, pickled fillings.

Tamago (sweet egg roll) comes last, as dessert!

SUSHI SATURDAY

Sushi's not exactly a quick, 20-minute meal to throw together on week-nights, so why not make a night of it and have Sushi Saturday?! It's a fun way to spend an evening together – invite your friends and everyone can join in to make a sushi feast (and then eat it)!

1 The first time you make sushi, it's quite likely your rolls will fall apart – so if you're inviting people round, practise first! Then you can look like a sushi master and impress everyone with your futomaki.

2 It's more fun if everyone joins in! While the rice is cooking, get your friends to help slice up the fillings.

3 Show your friends how to make a roll (start with a single filling 'hosomaki') then get them to try! Make sure their rice is neat and flat, and show them how it's done. Get an extra rolling mat or two so everyone can have a go.

4 Have a sushi competition – see who can make the best roll!*

*But even if your sushi rolls fall apart and look terrible, they'll still taste good!

MENU

Single filling rolls

Futomaki

Nigiri

Soy sauce for dipping

Pickled ginger

Gyoza

Edamame

Too hot for you?

Want snacks while you're rolling? Try wasabi peas, wasabi & ginger crisps or Japanese sweets.

Chopsticks are essential (and more fun)!

Sushi isn't everyone's cup of tea, so if any of your friends haven't tried sushi before, have a frozen pizza on standby just in case!

I'm the back-up!

AND TO DRINK ...
How about Japanese Ramune marble soda, brew up some green tea, or try a bottle of sake?*

*Contains alcohol